First published in Great Britain in 2022
Latch Patch Publishing
Shrewsbury
Shropshire

ISBN  978-1-9993765-2-9

ROSLYN HILL
CROCHET ART

Rethinking crochet the EASY WAY

This booklet is not a pattern for the faces on the cover. It is a guide on how to make a crocheted face of your own design using a unique and easy method.

## Skill Level

You will need to be able to sew patches together.

It is recommended for age aproximately 9 - adult.

Each stage needs to be worked through for the best results.

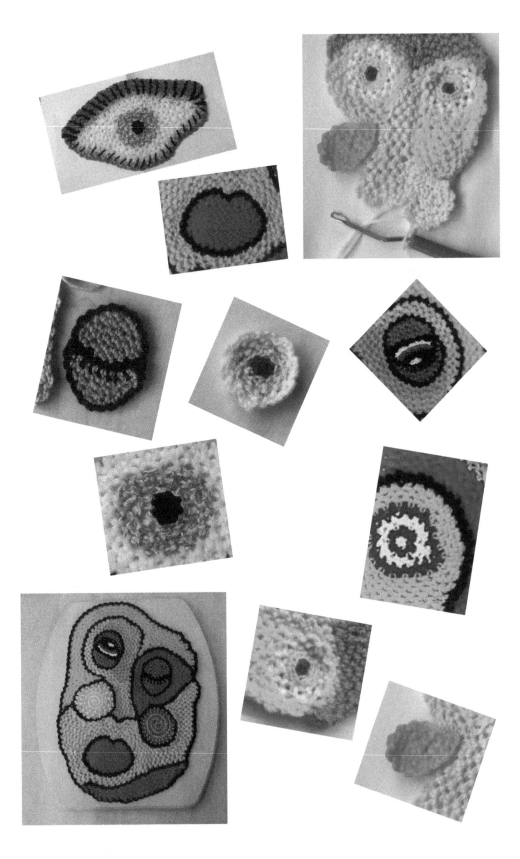

# Two Stitch Crochet

This new idea began when looking at the possible projects to teach beginners crochet. It has been an interesting topic and one that threw up a few surprises. I soon began to realize that few teachers do this and that it could be something new and a unique method of creating crochet. The simplicity is, that it is only necessary to teach two stitches and to learn two stitches.

These two stitches are chain and slip stitch and these are combined to make 'bridges. The best way to learn how to use these 'bridges' is to:-

1) make the bracelets to practice using different sized 'bridges'.

2) make a headband to learn how to increase the number of rows to make a fabric.

3) make some random patches to make separate elements that can be worked around or sewn together.

# There are a few things to note

- When making your first face you are creating your own design and there is no pattern to follow.
- It is intended to look original and it will evolve as you crochet.
- Once you have learned how to make the crochet 'bridges' you can use them freely to make the eyes, nose, cheeks and mouth, refered to as element or patches.
- Remember that you can make extra bridges or small loops when shaping each element.
- For several years I have been using a latch hook and this is how I would now normally teach beginners how to crochet. However, this project can also be done using a traditional hook.

## There are 3 stages to this project

1)Learning how to make the bracelets.
2)Learning how to make the two stitch fabric.
3) Learning how to make a face using the two stitch 'bridges' method.

# Bridges

Begin by learning how to make a chain.
Subscribe to my YouTube channel and follow
this link.
https://youtu.be/NCKerR4SDoU

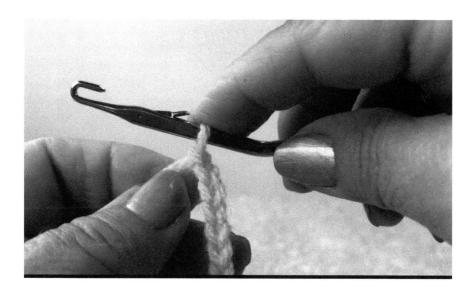

Now it is becoming apparent why it is not
necessary to begin the traditional way which is
to make a dishcloth and struggle to get the
sides straight. I always say there are no
mistakes in latch hook crochet just learning
curves. Each attempt can be kept as a
'treasure' and will come in useful later.

Next make the two colour bracelet using the YouTube link. https://youtu.be/cdoSGkOtvgc.

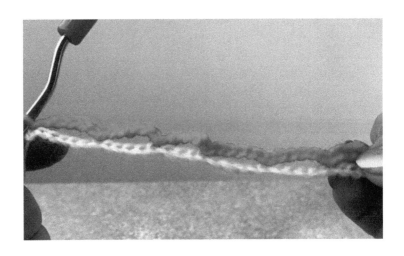

 The idea of making 'bridges' is that we can hook under them easily to make the slip stitch. The slip stitches of the first row are worked into the foundation chain. But for the second and following rows it gets easier as it is possible to hook under the bridges to make the slip stitch. The bridges (holes) are easy to hook under with the latch hook, although you may use a traditional hook.

 Begin with bridges made with 5 or 6 chains. Later make chains of 4, 3 and even 2 to make a tighter fabric.

# Bridges Bracelets

Making lots of these bracelets is recommended to get used to making the chain 'bridges'.

When making a face most of the time you will use bridges with 3 chains. However you can use turning chains with one or two stitches.

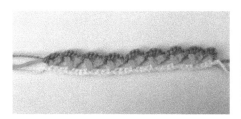 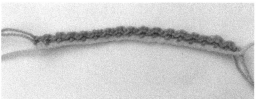

Practice making a
variety of chains using between 2and 5
chains between the slip stitches.

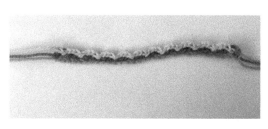 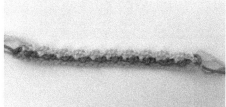

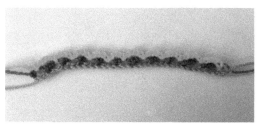 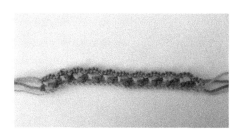

# Headband

Now it is possible to add more colours to your project to make a headband. There is no fixed way to do this. Generally I attach the next coloured yarn at the end of the two colour bracelet and make another row. Then add a further row. It is possible to join the yarn on the end of the work and work up to the top of the first loop. This method is neater as the headband gets wider. To finish I make one chain at the end pulling through all the coloured yarns at once.

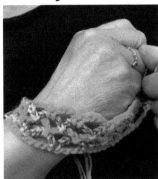 Make this bracelet first

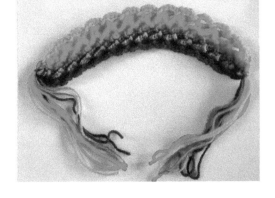

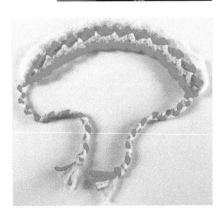

then some headbands

# Random Patches

Before attempting to make the face you may practice using bridges and coloured dk yarn to make some random latch patches.

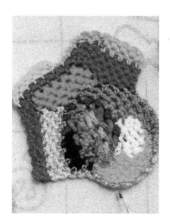

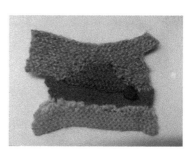
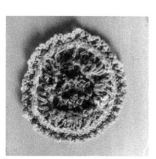
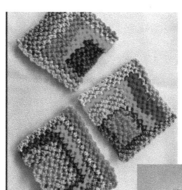

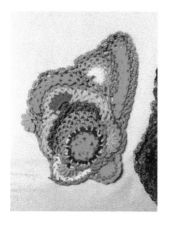
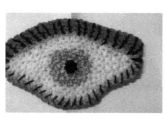
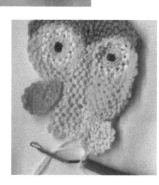

# Making circles

Before attempting the eyes you may practice making circles , so when doing this you may accidentally learn how to make a cone shape which is great!

When making a circle begin with 3 chain and hook into the first chain to make a tiny ring. Work around this ring using bridges of one chain length for the first round and two chain legnths for the next round. Then increase to 3 chain bridges. You will find that without any further increases it will begin to curve upwards. To keep it flat you must start to gradually increase the number of bridges. To achieve this in a freeform manner it will take practice.

This is important
You may increase by making a one or two bridges of 4 chains or make a bridge on top of a bridge in the previous row by hooking under a bridge twice.

# The face

Google face images for ideas. We are not using a pattern and the face can be designed using only chain and slip stitch. Its like drawing with yarn and because all the parts of the face can be any shape that you want them to be you can't get it wrong

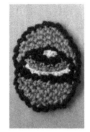

First make the eye,

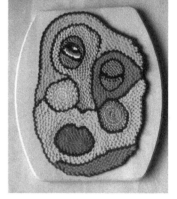

then begin around the left eye

and between both eyes.

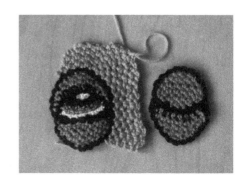

# The Eyes

Eyes can be as simple or as complex as you want them. Punch in 'eye images' in your browser. Or try 'eye drawing images' or even 'eye drawing cartoon images'. I have also researched animal and birds eyes this way.

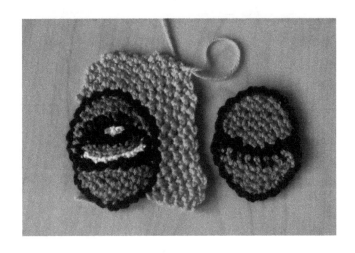

Making the eyes match is quite tricky. I opted for the closed eye because it was quicker, but I wondered if I would regret the quirkiness of it when finished. But then a beginner may like to go with this easy option of a sleeping face or even covering one eye with hair!

# Cheeks

For the cheeks I used two spiral circles and if
you are used to freeform crochet you can
make a similar design. However the easiest
way is to make the cheeks a plain circle. It
really doesn't matter if they are an irregular
circle or ovel shape. In another face I used two
paisley shapes for cheeks to fit in the face
nicely like cheek bones. I like to add a black
 bridges border around each element to make
them stand out, but to make it simple you
don't have to do this. You may want to first
sketch how the pieces are going to look in
position. The eyes, like mine, don't have to be
in line. Move the elements around to
wherever you want.

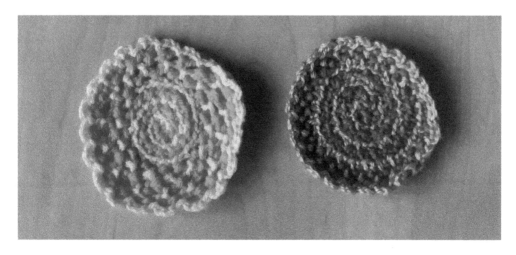

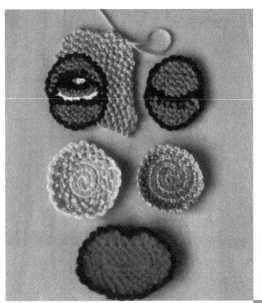

**Mouth**

**and**

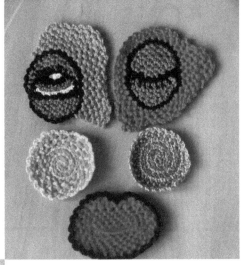

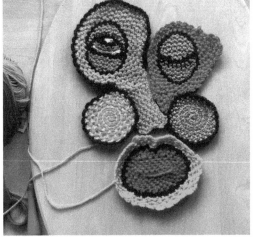

**Nose**

# Mouth and Nose

Decide the general shape of the nose and mouth and where you would like them to go. You can work the nose as separate patch or you can include it with one of the eyes as in my example.

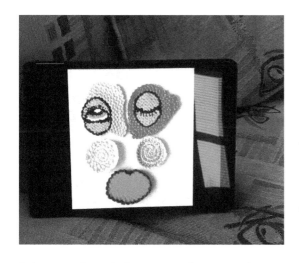

If you have access to a tablet, It may be helpful to veiw the work as a screen photo.

Now decide on the colours you want to fill in the rest of the face with. Begin by working around the outside of the eyes and also the outside of the mouth. Make extra bridges or small loops to add shape to the eyes and mouth. See the photograph and as you work the shapes can be stitched where they meet.

If you simply go around the mouth I found that it can become almost ape faced so its a good idea to extend to each side of the jaw, unless you would like it to be more animal like. I added a bottom line in purple to give a more shadow effect under the chin.

It is far better when making the face to expect some freedom of design because I don't count the stitches and therefore there is no exact pattern to follow. You may even like to extend the face to include hair, neck, shoulders, ears, hair adornments or jewellery. These can be added with crochet or with embroidery.

If you have enjoyed this project then do join the facebook group 'Crochet Art' where you can post photos of your own face project. Please leave a review and subscribe to my YouTube channel.

Roslyn Hill

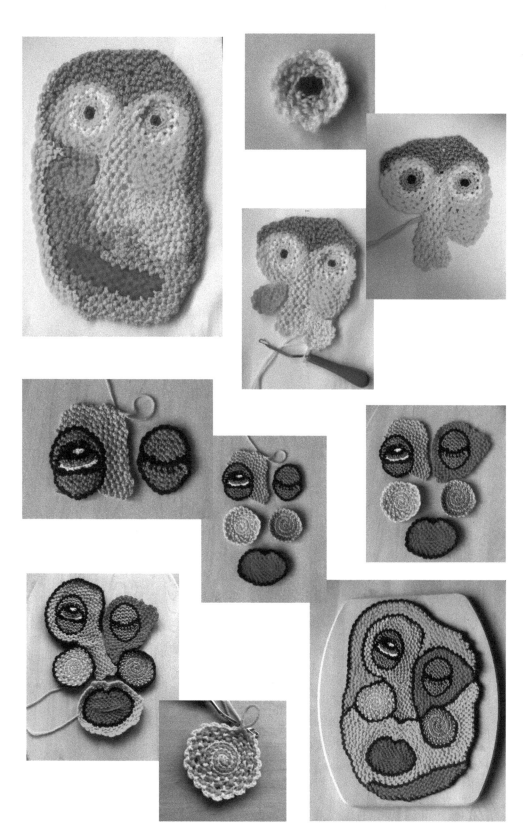

# Acknowledgements

Please join my groups where you may post and share your latch hook ideas with others:-
Facebook Page: Crochet the Easy Way
Facebook Group: Crochet Art
Blog: https://easycrochetblog.wordpress.com
Email: 4321roz@gmail.com
Subscribe YouTube: https://youtu.be/TowBfOgwFVQ

Business Coach : Proofread and mentored by Timea Ashraf

Angie Scarr

# Author

**Roslyn Hill B.Ed.** studied as an art teacher and is a retired primary school teacher. Working with textiles has been her passion, including felting, quilting, weaving, tapestry, knitting, machine knitting, canvas work and crochet, including freeform crochet.
Recently she is continually rethinking how crochet is taught, particularly with how children learn. Finding new and easy ways to encourage teachers to include crochet in the classroom.

CPSIA information can be obtained
at www.ICGtesting.com
Printed in the USA
BVHW021457310322
633014BV00004B/32